COMIC BOOK CHARACTERS

Comic book characters are popular not only in comic books, but also in graphic novels, blockbuster movies, and animated TV shows. This ultra-easy guide, with its clear, step-by-step art instruction, will show you how to draw cool comic book characters in the poses that make them exciting. You'll even learn some basic anatomy, which is helpful for every comic book artist. So get your pencil out and let's start saving the world from the forces of evil!

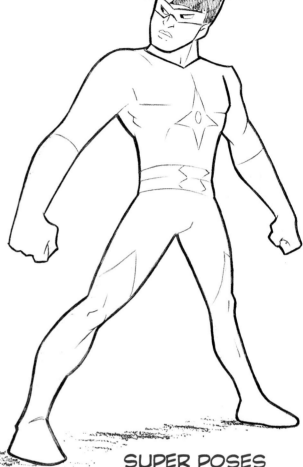

SUPER POSES

Whether they are good guys or bad guys, bold poses create dynamic characters.

SUPER POWERS

Although all superheroes are strong, special effects and dynamic costumes make them look even more powerful.

THE MALE HEAD

The typical comic book hero has a wide jaw and a squared-off chin to go with it. The neck is thick too, which indicates power. A lot of strong villains also have this look.

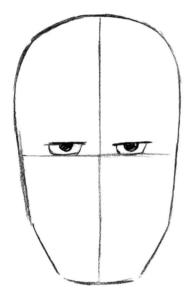

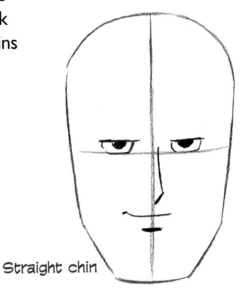

Straight chin

A small nose makes the jaw look bigger by comparison.

Make sure the eyeballs are cut off by the upper eyelids for an intense look.

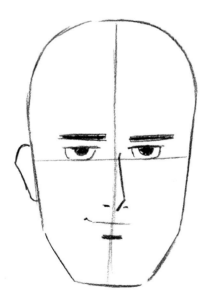

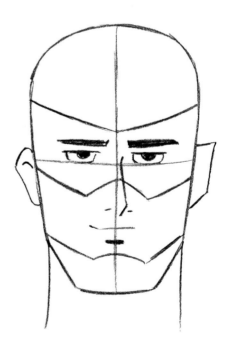

Muscular neck starts nearly at the ears.

Dark, straight eyebrows

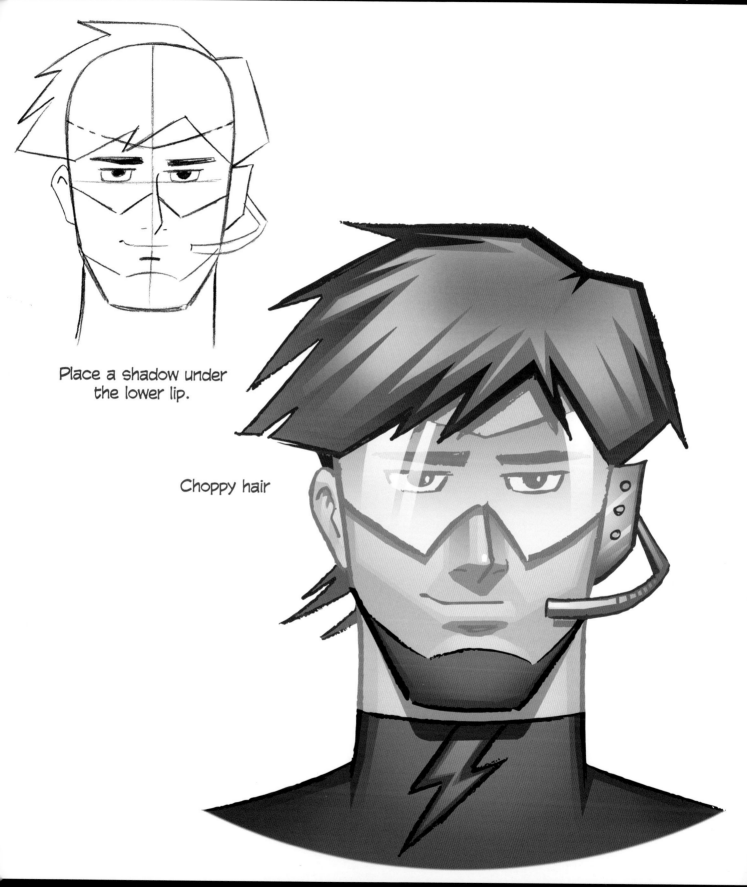

Place a shadow under
the lower lip.

Choppy hair

THE FEMALE HEAD

The top of the female head is the same as the male's, but the bottom half is quite different: it's rounder and the chin is tapered. The neck is thinner, too. The eyes are placed low on the head. Draw the nose lightly for an attractive look.

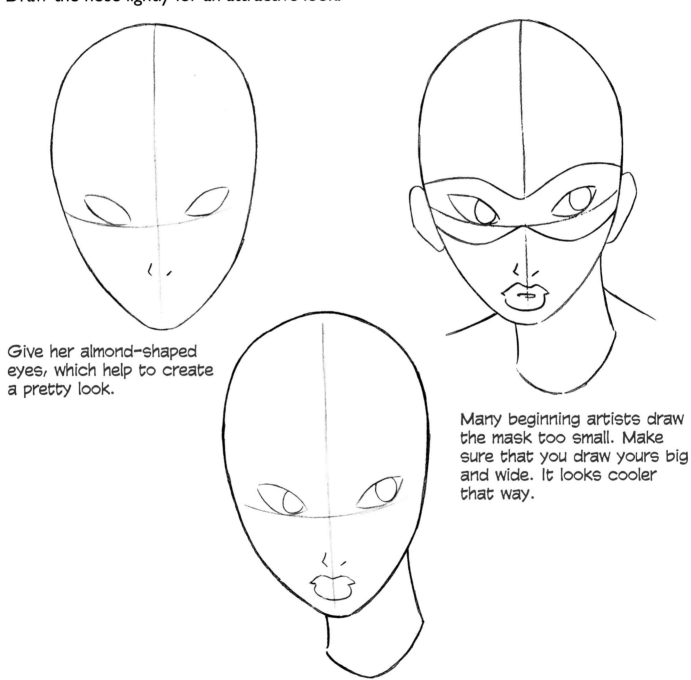

Give her almond-shaped eyes, which help to create a pretty look.

Many beginning artists draw the mask too small. Make sure that you draw yours big and wide. It looks cooler that way.

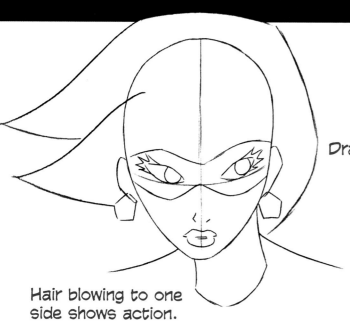

Draw thick eyelashes, not skinny ones.

Hair blowing to one side shows action.

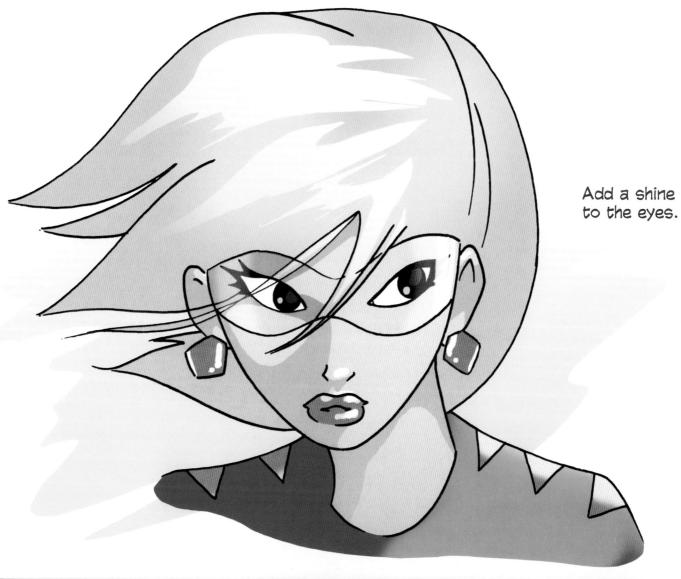

Add a shine to the eyes.

3/4 VIEW

By using a 3/4 view, your character can appear to face left or right, while still showing his or her face to the reader. In this view, the angle of the jaw is pronounced.

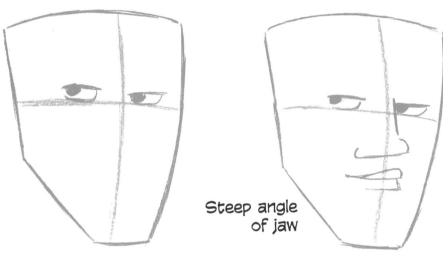

Steep angle of jaw

Short forehead, large jaw

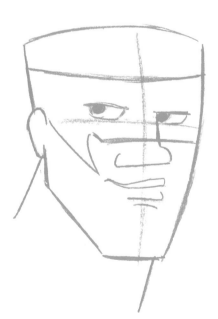

The wide neck angles off to the side.

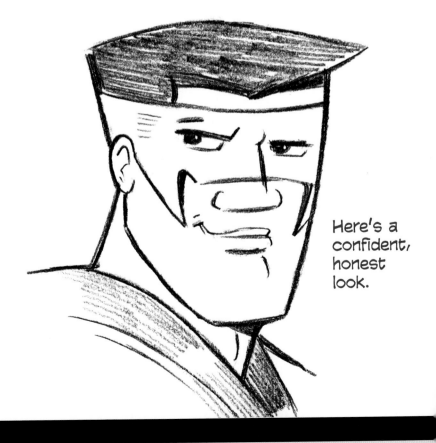

Here's a confident, honest look.

PROFILE

When drawing a side view, or profile, as it's also called, start by drawing the front of the face as if it were flat. Build the features to that foundation.

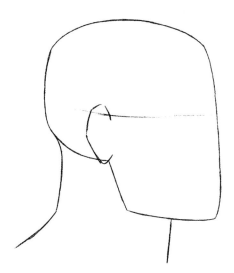

Low jaw angle for tough characters

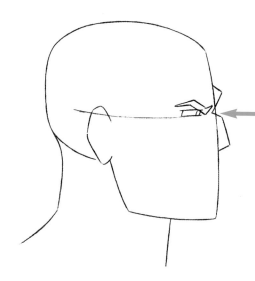

The eye goes where the bridge of nose starts.

Place the eye at the exact spot where the bridge of the nose and the forehead meet.

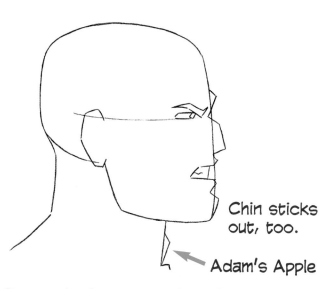

Chin sticks out, too.

Adam's Apple

On tough characters, like this fighter guy, the brow of the forehead sticks out.

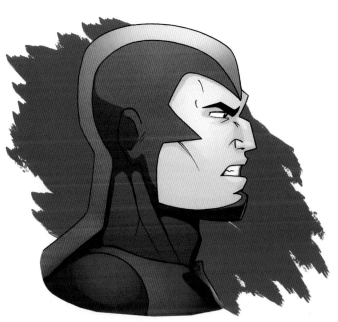

Once the basic head is in place, you can start to draw the costume.

MUSCLE GUY

Big bruisers are built with a thick skull and a thick body. Don't be afraid to exaggerate his girth. Today's comics are extreme. Let's begin with a granite block, also known as his head!

The super-wide cheekbones protrude.

The contour lines of the cheekbones travel into the face.

Tiny skull

Super-wide neck

Small but steely eyes

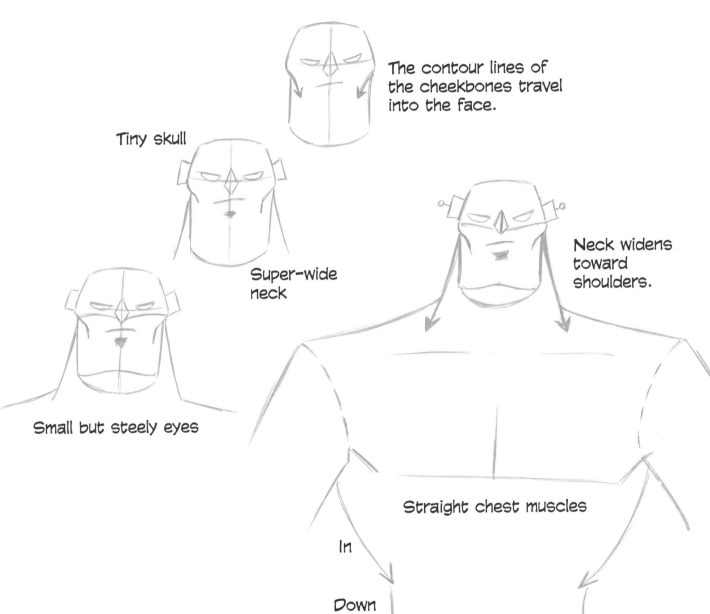

Neck widens toward shoulders.

Straight chest muscles

In

Down

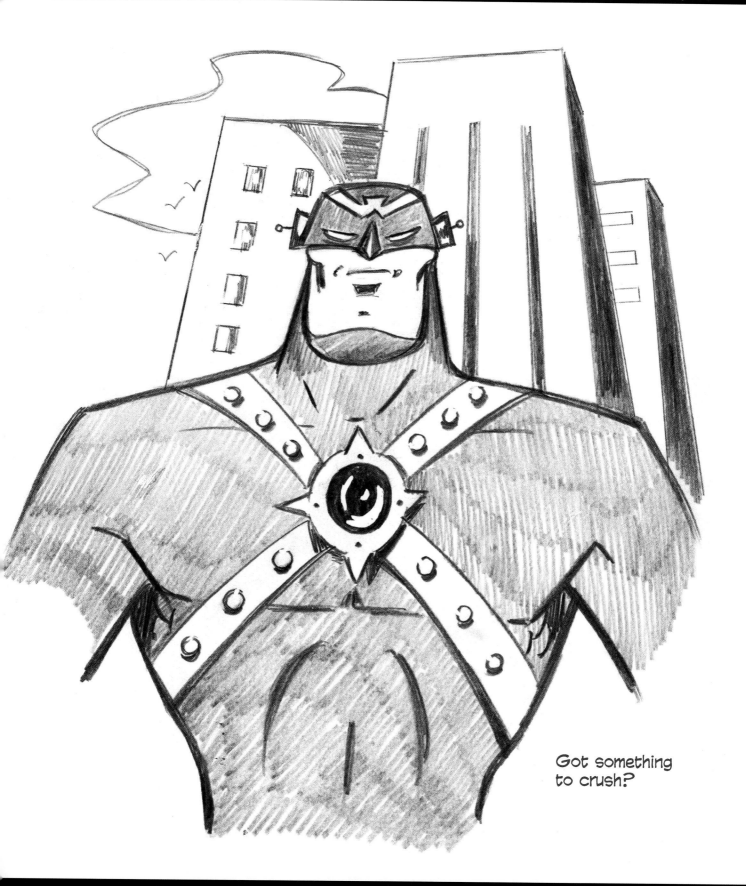

Got something
to crush?

MASKED GIRL

Masks do more than create superhero identities, they can also give a character a mysterious appearance. This one is mysterious, beautiful, and dangerous. I don't trust a superhero who wears spiders for earrings.

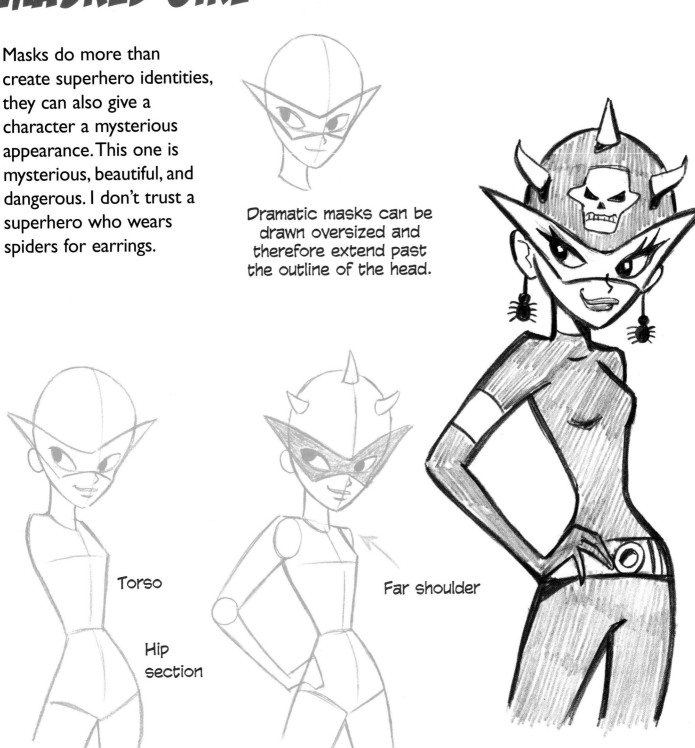

Dramatic masks can be drawn oversized and therefore extend past the outline of the head.

Torso

Hip section

Far shoulder

Good poses are based on curves; they are rarely straight.

TIP: Vary the Poses

Superheroes exude self-confidence. But a sturdy stance can sometimes look stiff. To avoid this, try varying the placement of an arm or a leg. For example, this female superhero-warrior has one leg crossing in front of the other. A little change like this creates more interest in the pose.

The heroic stance is proud, with the back arched and chest held high.

Indent at the waistline.

Draw the underlying leg, too, for positioning.

A large shield makes a fighter look formidable.

YOUNG HERO

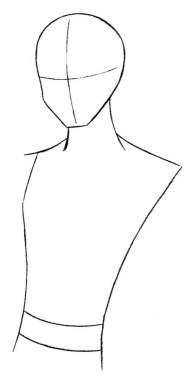

The young hero doesn't have the huge muscles of the more mature hero characters, but his expression is just as intense. Plus, he's got a cool costume and can handle a neutrino laser as well as anyone this side of the Orion Belt.

Sketch out a thin but athletic upper body.

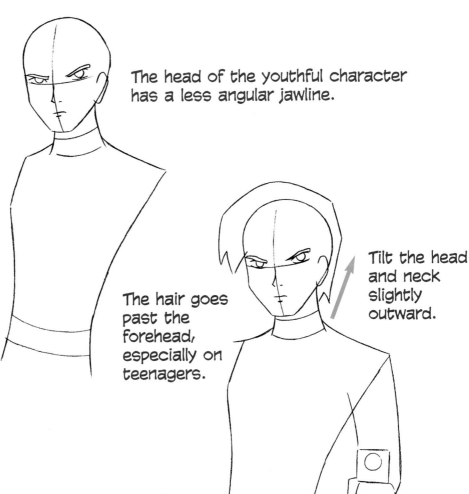

The head of the youthful character has a less angular jawline.

The hair goes past the forehead, especially on teenagers.

Tilt the head and neck slightly outward.

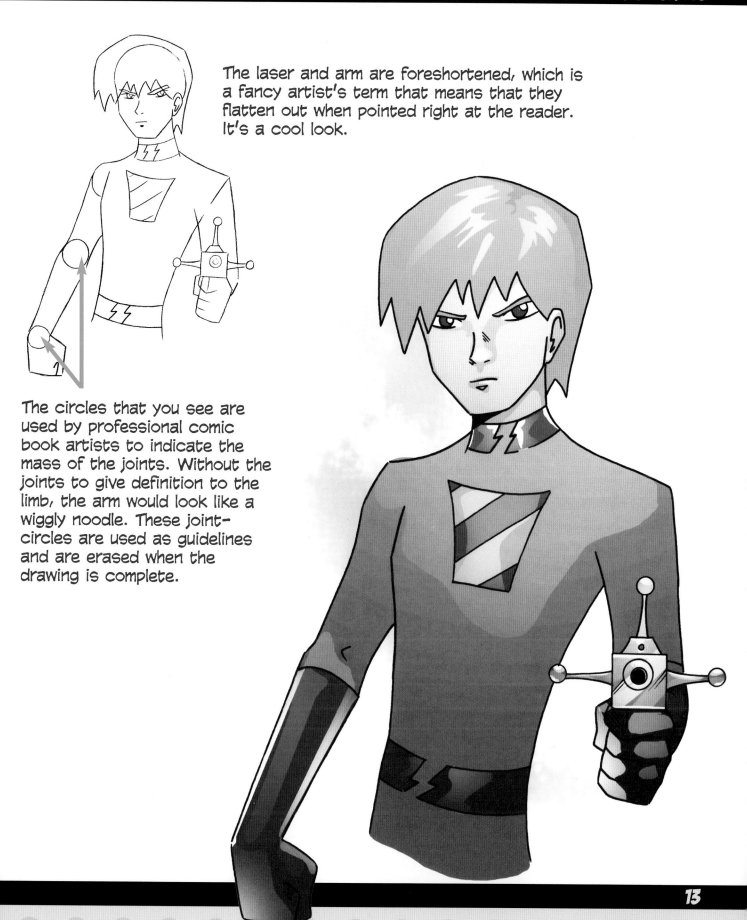

The laser and arm are foreshortened, which is a fancy artist's term that means that they flatten out when pointed right at the reader. It's a cool look.

The circles that you see are used by professional comic book artists to indicate the mass of the joints. Without the joints to give definition to the limb, the arm would look like a wiggly noodle. These joint-circles are used as guidelines and are erased when the drawing is complete.

THE CLASSIC COMIC BOOK POSE

This is a classic stance for action figures. Note how wide the upper body is at the shoulders and how narrow it is at the waist. This is called a "V"-shaped body.

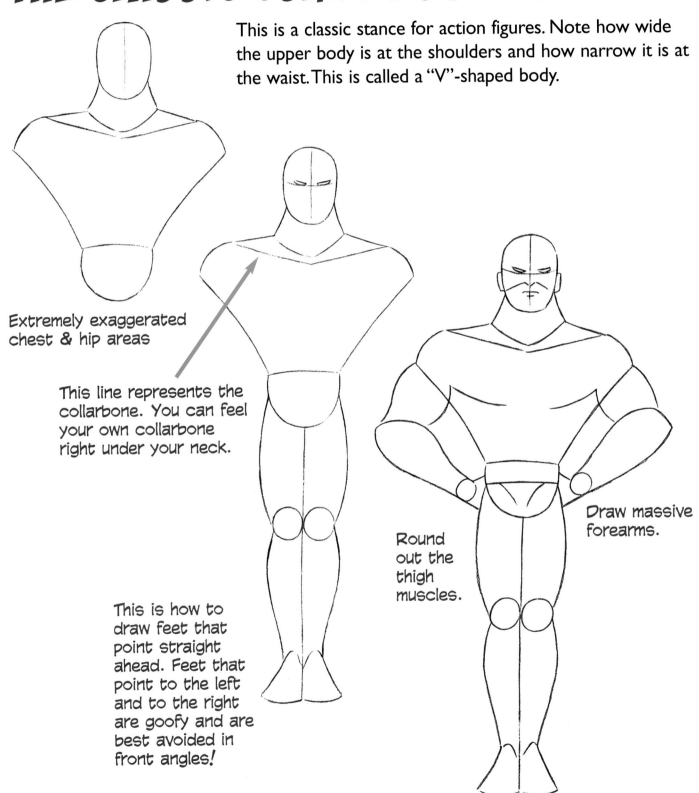

Extremely exaggerated chest & hip areas

This line represents the collarbone. You can feel your own collarbone right under your neck.

This is how to draw feet that point straight ahead. Feet that point to the left and to the right are goofy and are best avoided in front angles!

Round out the thigh muscles.

Draw massive forearms.

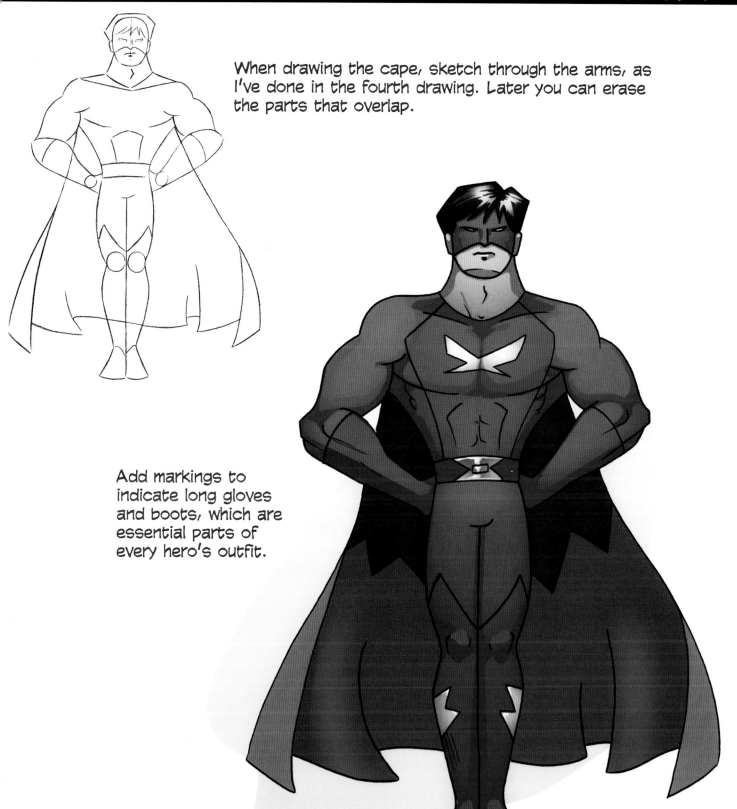

When drawing the cape, sketch through the arms, as I've done in the fourth drawing. Later you can erase the parts that overlap.

Add markings to indicate long gloves and boots, which are essential parts of every hero's outfit.

FEMALE FIGHTER

This type of posture shows an interesting attitude—sort of playful, yet dangerous. Find inventive ways to demonstrate your character's personality through your poses.

Place the eyeballs in the corners of the eyes, under long lashes for a clever expression.

The neck travels into the upper body.

A raised shoulder shows attitude.

The shoulders and the hips are equally wide.

The front knee overlaps the far knee.

The straight leg is bearing most of the weight of the pose. The relaxed leg is bent.

Flare out the shoulders just a bit, to create a stylish uniform.

The line that runs down the middle of her body bends in and out, to show the contours of her figure, which in turn makes her look more three-dimensional and less flat.

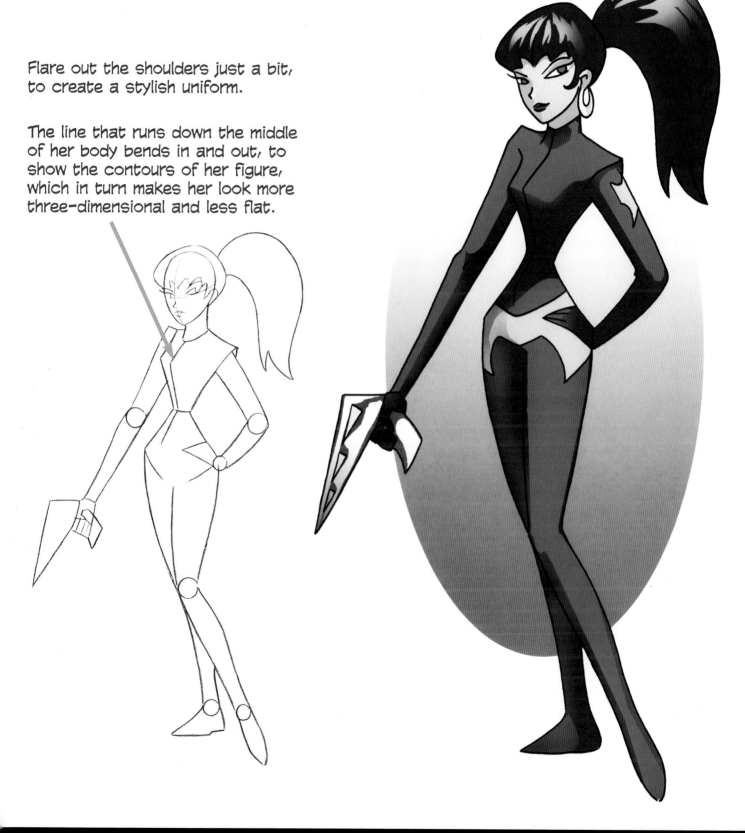

DEFENDING THE INNOCENT

This character's pose, with legs wide apart and fists clenched at his sides, means he's ready for trouble. It's an easy pose to draw because it's symmetrical. That means that the arms and legs on the left side are mirror images of the arms and legs on the right side—it's perfectly balanced.

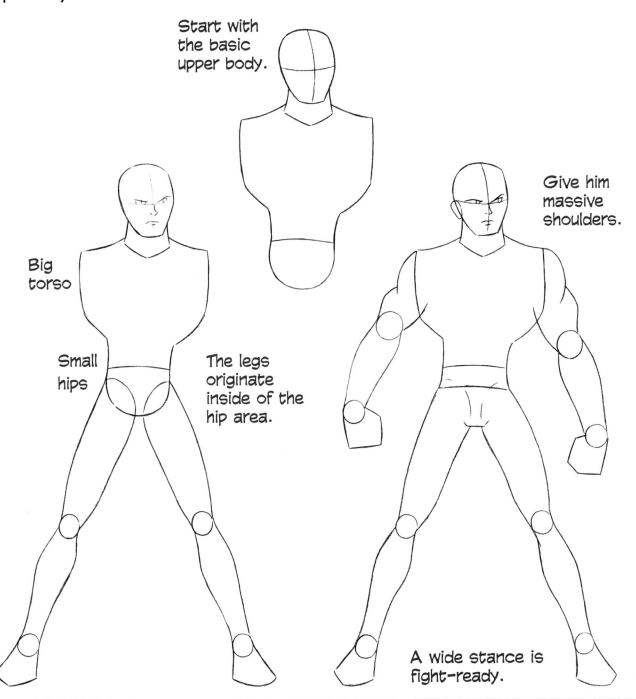

Start with the basic upper body.

Big torso

Small hips

The legs originate inside of the hip area.

Give him massive shoulders.

A wide stance is fight-ready.

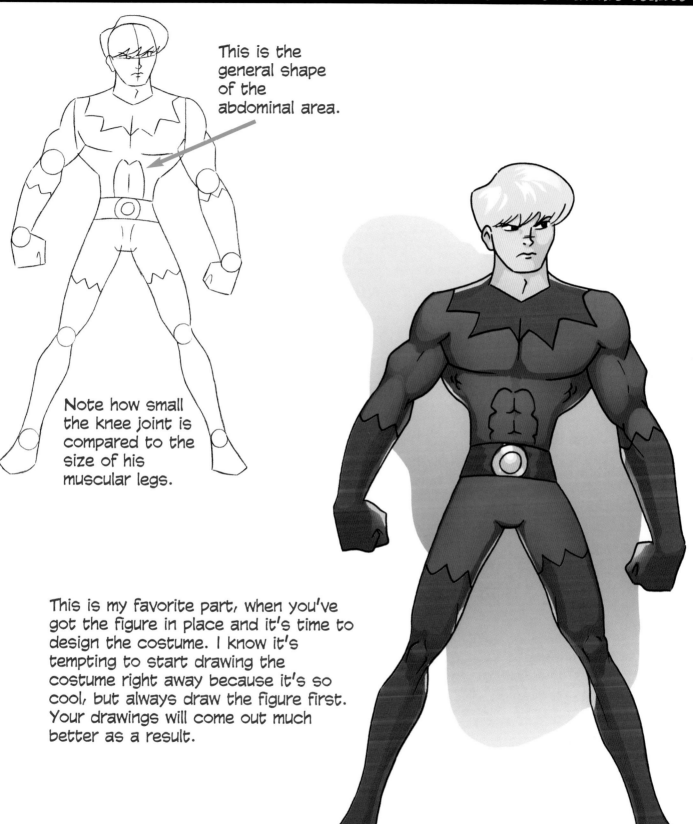

This is the general shape of the abdominal area.

Note how small the knee joint is compared to the size of his muscular legs.

This is my favorite part, when you've got the figure in place and it's time to design the costume. I know it's tempting to start drawing the costume right away because it's so cool, but always draw the figure first. Your drawings will come out much better as a result.

BOY HERO

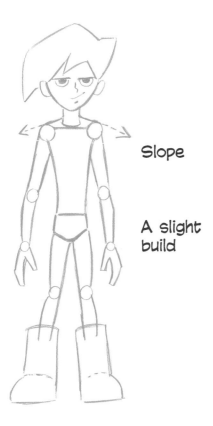

Slope

A slight build

Oversized boots add a bit of humor to this character type.

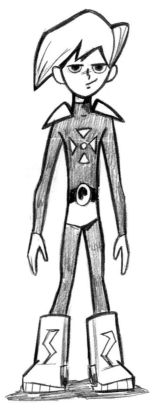

Some of the most popular comic book characters are unlikely heroes. This includes the brave young kid. Clearly underpowered in size, he is nevertheless a fearless fighter.

Floppy hair

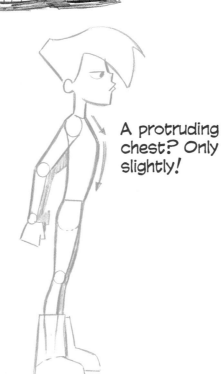

A protruding chest? Only slightly!

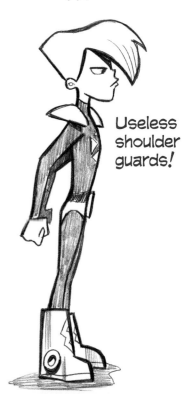

Useless shoulder guards!

FUNNY BOY

If there's a boy hero, then there's got to be a boy anti-hero. This is the evil classmate in superhero school who never got over his grudge.

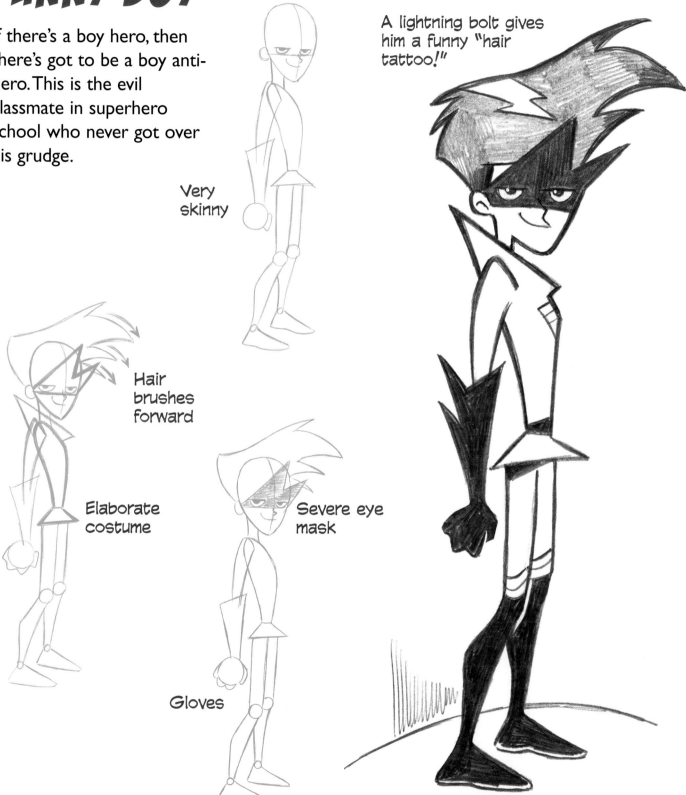

Very skinny

A lightning bolt gives him a funny "hair tattoo!"

Hair brushes forward

Elaborate costume

Severe eye mask

Gloves

ACTION & SIMPLICITY

Action poses may look complex but they are actually based on a simple principle: a basic pose is most effective when it appears to follow a single direction, as indicated by the arrows.

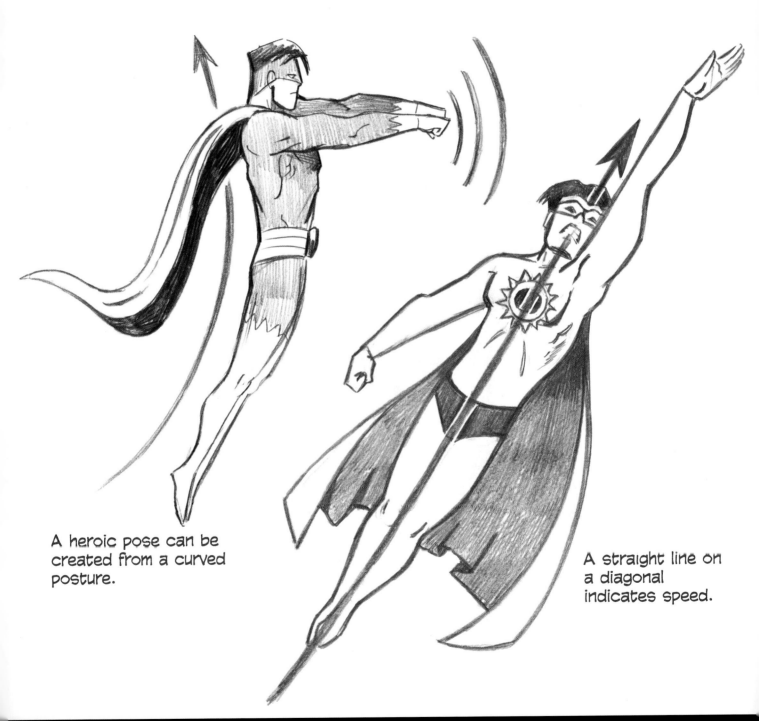

A heroic pose can be created from a curved posture.

A straight line on a diagonal indicates speed.

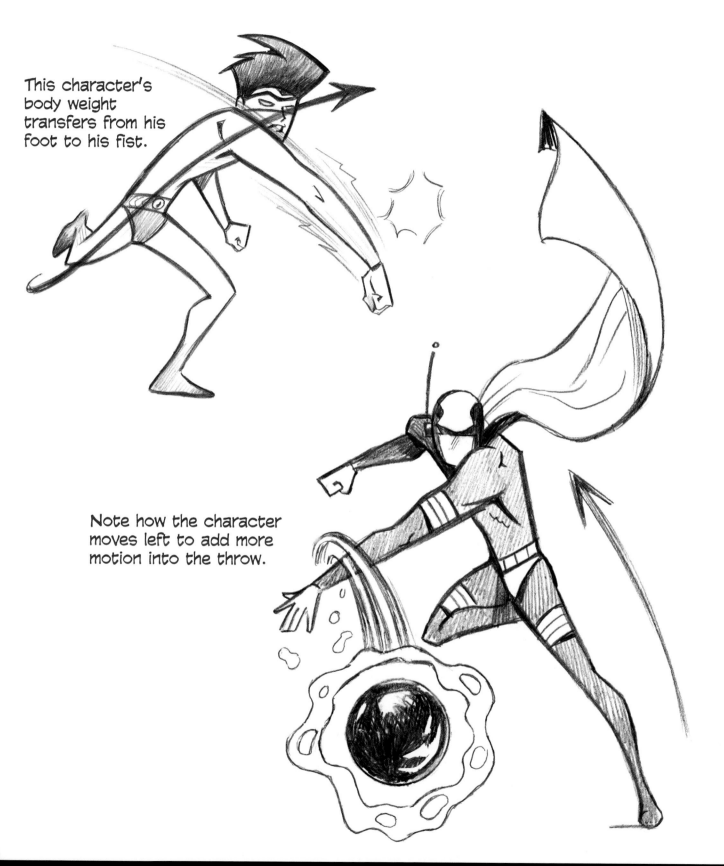

This character's body weight transfers from his foot to his fist.

Note how the character moves left to add more motion into the throw.

RUNNING LIKE LIGHTNING

When action heroes run, they're as fast as lightning. But how does one achieve the look of lighting-fast speed in a pose? Draw the legs in a stride that is super-long, and angle the torso forward at a diagonal. And the arms have got to be pumping hard! Last, the character must be in mid-air, with neither foot touching the ground.

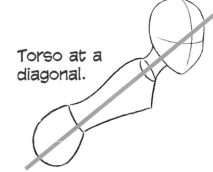

Torso at a diagonal.

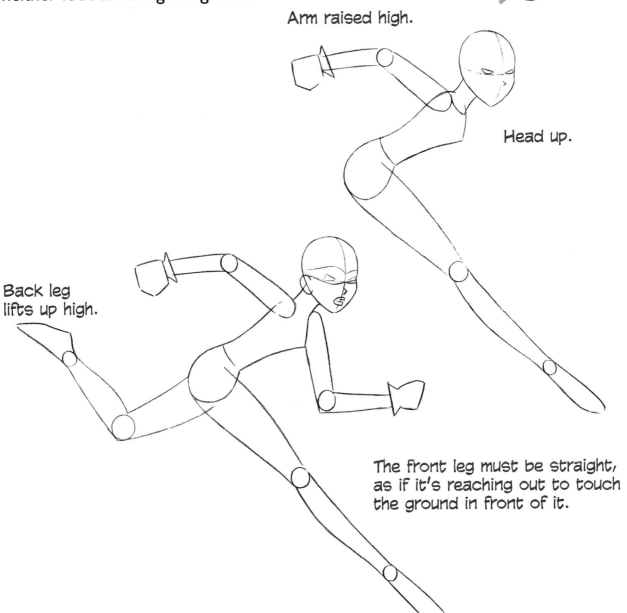

Arm raised high.

Head up.

Back leg lifts up high.

The front leg must be straight, as if it's reaching out to touch the ground in front of it.

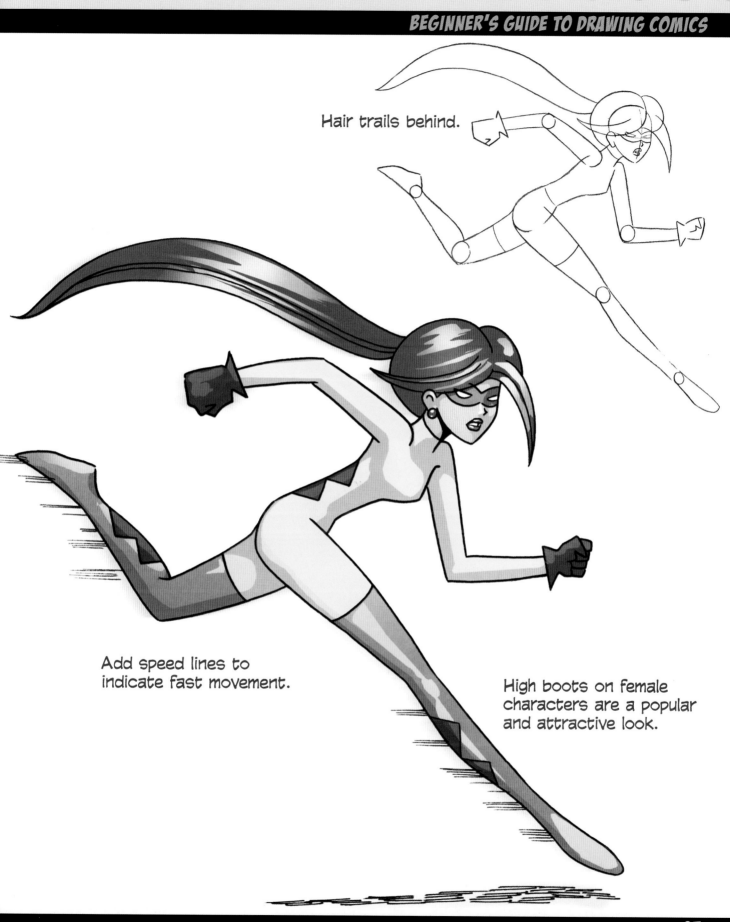

Hair trails behind.

Add speed lines to indicate fast movement.

High boots on female characters are a popular and attractive look.

ACTION POSE

This skillful fighter has a secret talent: he can throw sharp disks with precision, knocking a weapon from an enemy's hand before he knows what hit him. To make the pose dynamic, make sure to get the front shoulder into the movement.

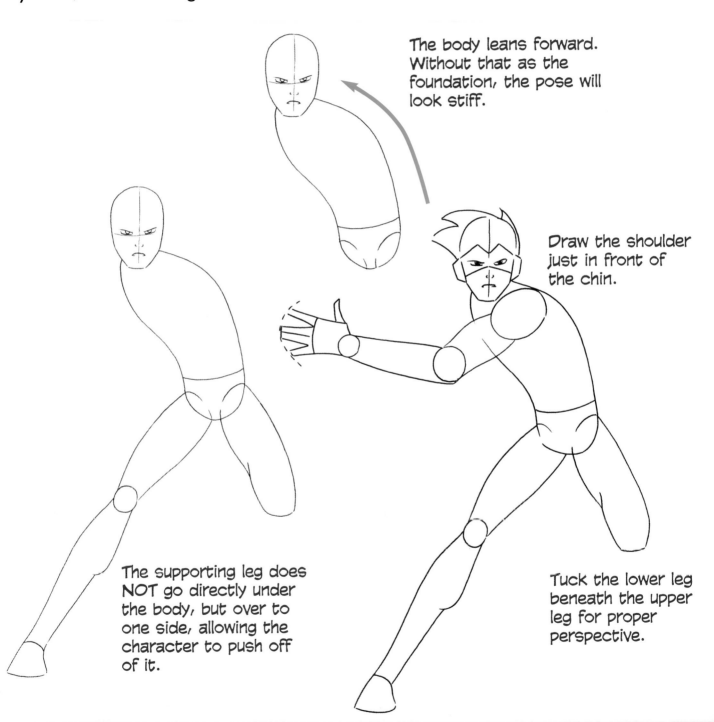

The body leans forward. Without that as the foundation, the pose will look stiff.

Draw the shoulder just in front of the chin.

The supporting leg does NOT go directly under the body, but over to one side, allowing the character to push off of it.

Tuck the lower leg beneath the upper leg for proper perspective.

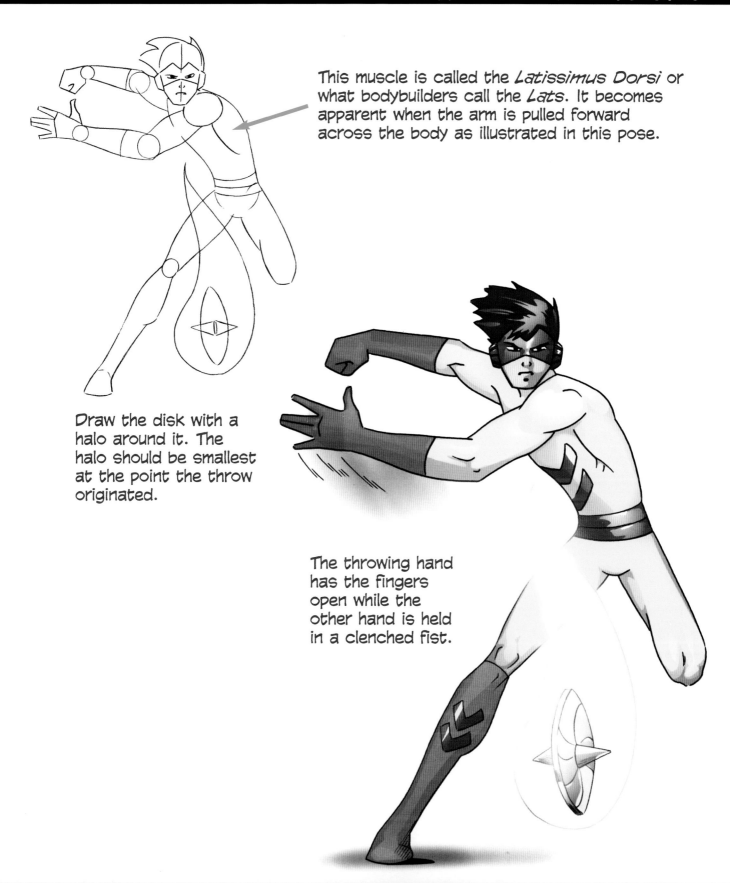

This muscle is called the *Latissimus Dorsi* or what bodybuilders call the *Lats*. It becomes apparent when the arm is pulled forward across the body as illustrated in this pose.

Draw the disk with a halo around it. The halo should be smallest at the point the throw originated.

The throwing hand has the fingers open while the other hand is held in a clenched fist.

SCISSOR-CLAW

You can always tell the bad guy in comics. He's the character who looks like he could eat a tractor-trailer for lunch and top it off with a couple of delicious minivans. His costume often looks painful for his opponents. He does not play nicely with others.

Long upper body; short lower body

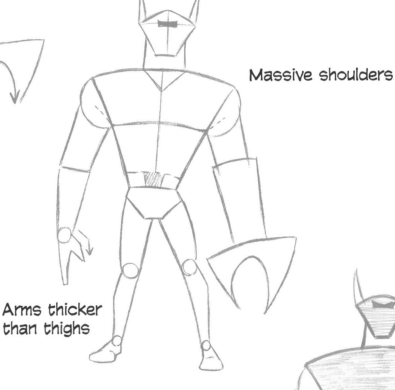

Massive shoulders

Arms thicker than thighs

Note the construction: the character is built with basic shapes.

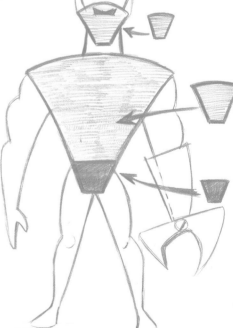

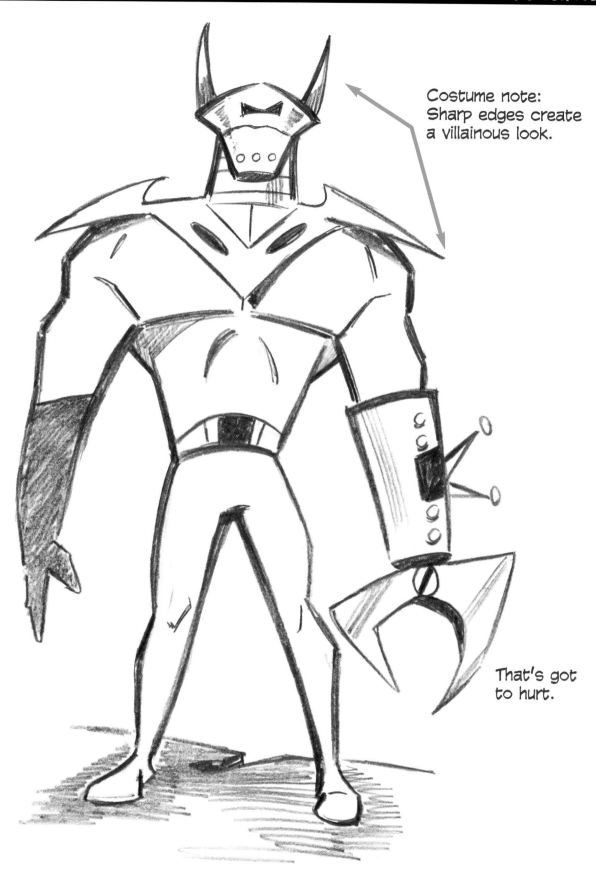

Costume note: Sharp edges create a villainous look.

That's got to hurt.

BURGLAR

Thugs are popular bad-guy characters. They are typically brawny, but dim-witted. The head is very angular, to create a hardened look to the character.

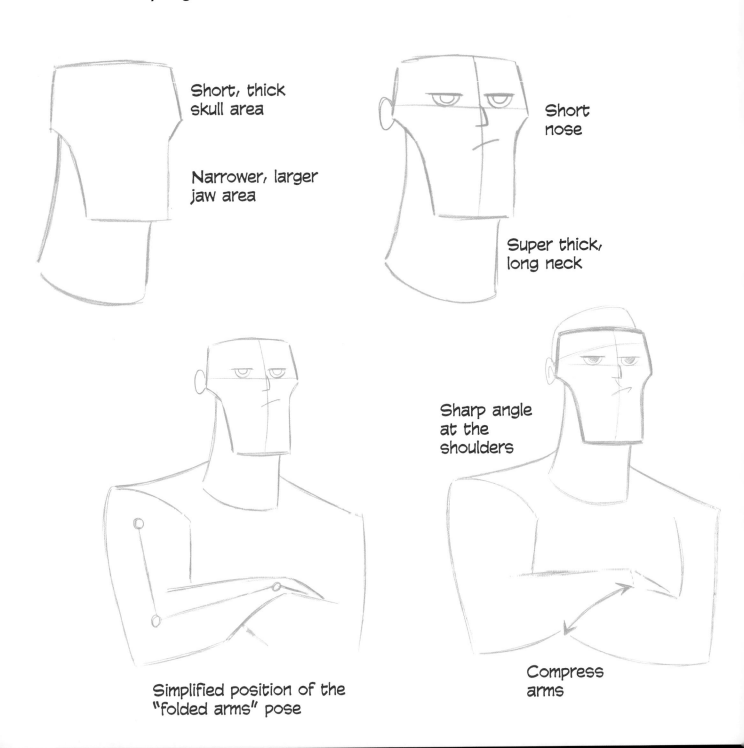

Short, thick skull area

Narrower, larger jaw area

Short nose

Super thick, long neck

Sharp angle at the shoulders

Simplified position of the "folded arms" pose

Compress arms

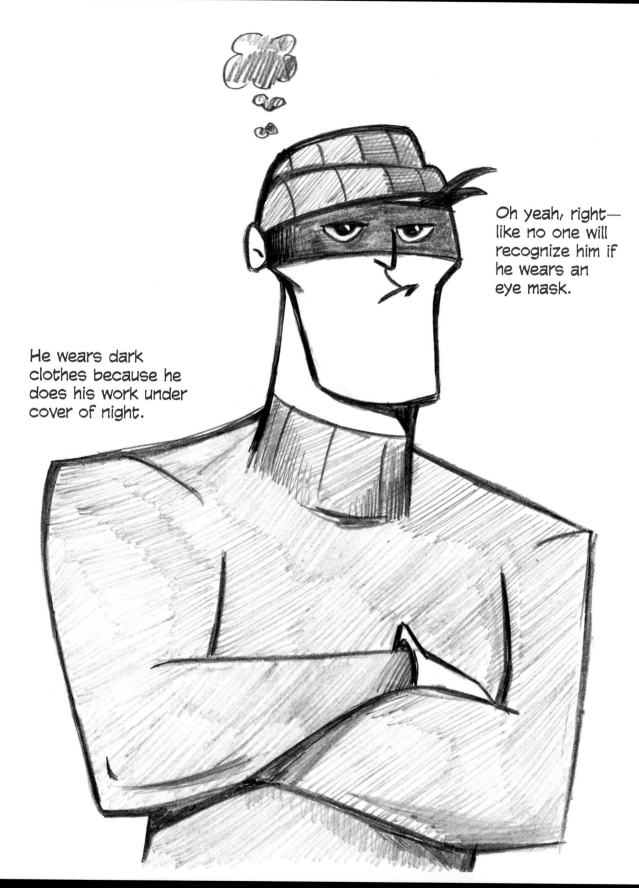

Oh yeah, right—
like no one will
recognize him if
he wears an
eye mask.

He wears dark
clothes because he
does his work under
cover of night.

GLOPPY GUY

Never try to make friends with a
walking glob of green sludge.

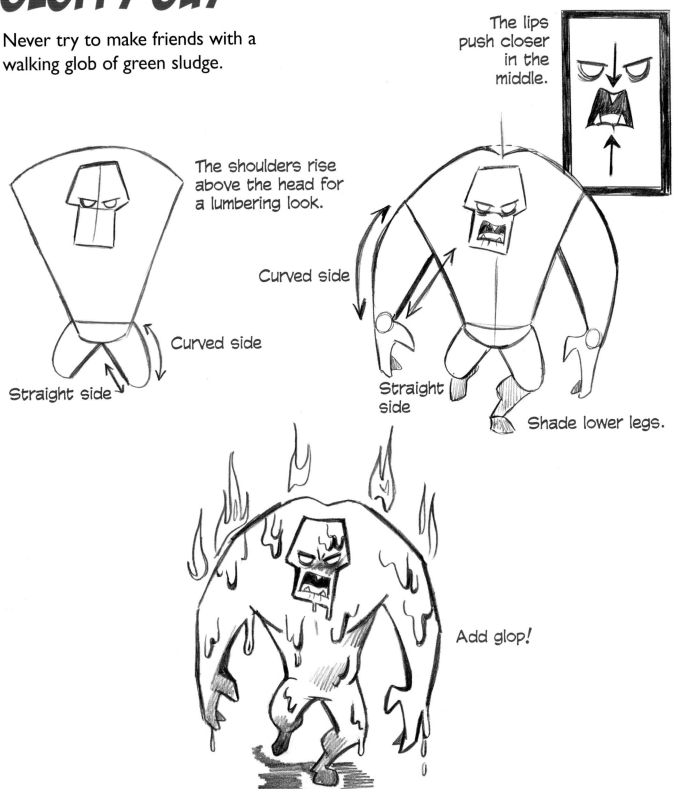

The shoulders rise
above the head for
a lumbering look.

Curved side

Curved side

Straight side

The lips
push closer
in the
middle.

Straight
side

Shade lower legs.

Add glop!

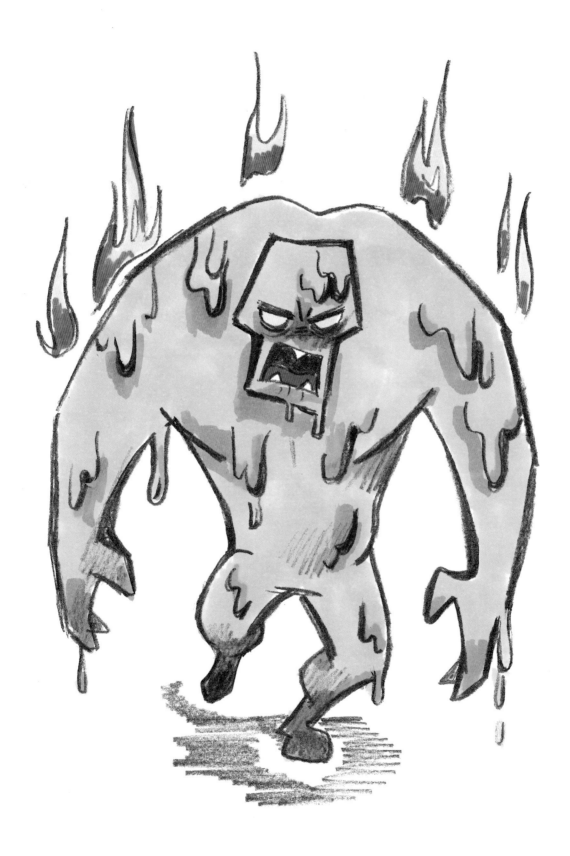

YOUR HOW-TO-DRAW SHERPA

Christopher Hart is the world's best-selling author of how-to-draw books. His books have sold over 6 million copies, and have been translated into 20 languages.

Please visit Christopher Hart online:
OFFICIAL WEBSITE: www.christopherhartbooks.com
FACEBOOK: www.facebook.com/LEARN.TO.DRAW.CARTOONS
YOUTUBE: www.youtube.com/user/chrishartbooks

$9.95 U.S./$11.95 Canada

ISBN: 9781942021124

9 781942 021124

Student Resources

Houghton
Mifflin
Harcourt

GO MATH!

Common Core